Kristy Rice

Painterly Days

The *Flower*

WATERCOLORING BOOK

for Adults

CONTENTS

Schiffer Publishing Ltd

4880 Lower Valley Road • Atglen, PA 19310

Dedication

To my Lord and Savior for teaching me the meaning of true joy.
To my husband, Adam, for never wanting me to be someone I'm not.
To my parents, Fulton and Linda, for giving me wings to fly and room to be messy.
And to Unkie, who taught me to keep my nose to the grindstone.

Epigraph

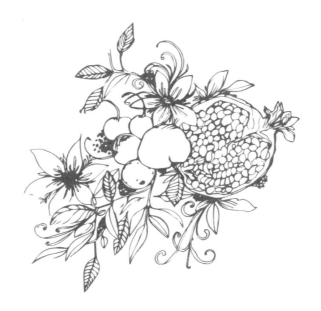

I went down to the nut orchard to look at the blossoms of the valley, to see whether the vines had budded, whether the pomegranates were in bloom.

Song of Solomon 6:11 ESV

ANEMONES

I've been drawn to anemones for most of my adult life. Maybe it is their dark, velvety centers, the paper-thin petals or bold, bright colors, but regardless, anemones make me happy. So pick up the brush and dive in. No color is wrong or better than the other.

Painting tip: Mix a random variety of colors together to obtain a rich, blackish color for the centers of each bloom.

On being an artist: Artists are always beginners. You don't need to paint for years to call yourself an artist. You only need a desire to create something, just for the sake of it. No deadlines, no judging, no right or wrong . . . simply make.

BERRIES

This pattern is pure fun. Most of the details are imaginary and began in a doodling session. Some blooms resemble peonies, some roses, and there may even be a raspberry or two thrown in. Mysterious greenery gives the pattern a nice sense of movement.

Painting tip: Sometimes we need to simply let go of all the "should haves" that fill our brains. Do you feel like painting a leaf pink? Go for it. Has painting a leaf pink never crossed your mind? Try it.

On being an artist: Artists have a stigma—that we are free spirits who worry about nothing and spend our days dreaming. Not quite. But like the rest of the population, we do need to take time to daydream and be silly once in a while. Let today's painting session be your silly time. Go ahead, be brave and be silly!

"Courage, dear heart." —C. S. Lewis

BOTANICAL

This pattern came to life after I studied vintage botanical prints for some time. The goal was to create an updated version of the quintessential botanical illustration while maintaining some of the lovely details for which vintage prints are known.

Painting tip: Not all areas of the painting need to feature the same amount of detail. You can have a lot of fun by focusing a lot of detail in one area but perhaps just wash a color or two in another.

On being an artist: Artists practice restraint. Throughout history, painters are also known as thinkers. What do I mean by this? Artists take meditative time to consider, plot, and play around with ideas in their head before they even touch brush to paper.

"There is no art without contemplation." —Robert Henri

CHERRY BLOSSOMS AND GARDEN ROSES

This pattern reminds me of old-style tattoos. Simple lines and stylized forms give a bold face to traditional cherry blossoms and garden roses.

Painting tip: One of my favorite techniques is a trick I learned a while back. Wet just one petal in a bloom. Dry your brush completely and then dip just the tip back into clean water. Add a good amount of your chosen pigment from your palette. Go back to the wet petal and line it with color along the edges, without pressing too hard. You'll see the paint begin to bleed into the wet petal. Like that effect? Brush on more clean water. When dry, the outer edge of your petal will fade into the middle.

On being an artist: Artists are willing. Being a painter mostly requires a willingness to look, listen, and be still. Painters are curious and patient and learn to avoid distraction (it is so hard!). Buy materials you can afford, set up in a spot that makes you feel at home.

HEIRLOOM PEONIES

If one pattern in this book is more advanced than the others, this would be it. I mention this not to scare you, but to encourage a more lingering examination of the pattern before beginning. Leaves and stems and petals overlap in a way that a quick glance could miss. The tiniest details make themselves known only after your third or fourth look.

Painting tip: Think about the areas you may want to leave unpainted to accentuate certain blooms. Perhaps you might leave the very centers of each peony alone to call attention to a bolder color you place behind it. Leaving areas white in your painting can be difficult.

We're tempted to cover the entire page, yet a bit of white gives all the remaining color and detail some breathing room.

On being an artist: Artists strive to be fearless. As adults, we expect so much from ourselves. I recall teaching seven-year-olds how to paint and draw during my college years. Their lack of fear offered them a trait that all artists need to develop—confidence. I always tell myself, "It's just paper, get on with it!"

PEONIES AND BUTTERFLY

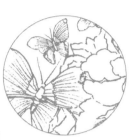

Inspired by the imaginative wallpapers of iconic interior designer Dorothy Draper, this pattern is a lesson in "less is more." There is just one type of bloom here, along with the enchanting butterfly.

Painting tip: Try using shimmering inks as a finishing touch (see suggested materials). They can add a wonderful dimension and visual power.

On being an artist: Artists are opportunists. Dorothy Draper (1889–1969) lived and breathed her art, which happened to be interior design. She insisted on complete control over nearly everything in a client's interior, from the design on the dinnerware and bathroom wallpaper to wait staff uniforms and restaurant menus. Draper owned her artistry with unfailing confidence. So I encourage you to be the artist in increasing ways throughout your day. Sketch on your kids' lunch bags. Take practice sheets of watercolor paper and make gift tags, line the inside of your kitchen cabinets with inspiring art quotes—immerse yourself.

POPPIES

Icelandic poppies might be my favorite flower. Paper-thin petals that crinkle and glisten in the light seem like they were made to be watercolored. This poppy variety is typically seen in shades of peach, yellow, and white, but I've left room in this pattern for you to explore your own love affair with poppies.

Painting tip: Paint the petals in clean water first and drop in shades of color. Let the color explode into the water. Be patient and let it dry without adding more brushstrokes. The result will amaze you.

On being an artist: Artists avoid comparison. Theodore Roosevelt had it right when he said that comparison is the thief of joy, and this book is meant to help you discover joy. So promise yourself that during your painting sessions you won't browse Instagram or flip through an art book to see how others have done it. You are the artist here, and you call the shots. You can do research earlier or later.

TROPICAL

In Punta Nizuc, Mexico, exquisite trees drip with bright red-orange blooms that resemble gladiolus. They are surrounded by large, shiny green leaves and pods of soft sage green. I found the combination of shapes interesting, so I created this lush, verdant pattern celebrating warm-climate landscapes.

Painting tip: For an intense shade of red, layer your watercolor. Add the first layer, let dry, add another, and continue until you've reached your desired color intensity. It is a repetitive but cathartic process.

On being an artist: Artists know when to stop. If you are feeling distracted or disinterested, stop. Start a new painting, get fresh painting water, or clean your brushes. Then come back to it later, knowing your brain is refreshed and ready to go.

VIOLETS

My mom has been growing violets on her windowsill for as long as I can recall. These unfussy plants are easily overlooked, as most of the year they have no flowers to speak of. When they start to bloom, tiny, ruffled petals appear ranging from the softest pink to intense violet. This pattern is dedicated to my mom and her love of these beauties.

Painting tip: Purple is a tricky color. If undiluted, it can feel wild and overwhelming, but when mixed with a good portion of water it becomes light and hopeful.

On being an artist: Artists are students. Part of becoming an artist, whether you hope to eventually sell your work or simply want a creative outlet, is to research other artists. (Remember, though, not during painting sessions.) We can learn so much from our fellow artists and

begin to see their experiences in ours, creating an inspirational kinship from afar. I've always admired artist Marjolein Bastin for her exquisite use of soft colors. She has the ability to keep her color palettes muted and gentle to evoke a calming feeling. Take a moment to explore her work, even if only though a quick Google search.

MOCK ORANGE

When we moved into our home, someone gifted us with this tiny, sweet smelling plant. I had no clue what it was, but set it in the earth, and to this day the plant produces the most glorious explosion of white blooms in early spring. Eventually, I discovered it was mock orange, which aptly describes its delicious smell.

Painting tip: Painting white flowers can seem tricky. First, let me remind you that painting flowers just as they occur in nature is not a requirement. But if you are more of a realist, consider this: Nothing in the natural world is stark white. The colors of seemingly white petals, berries, and textures reflect their surroundings. A hint of sheer blue or a wash of golden tones in a particular spot on the page will bring life to white blooms without making them seem heavy or unnatural.

On being an artist: Artists surround themselves with inspiration. A small collection of well-kept houseplants on a windowsill can bring just as much joy as a cutting garden full of blooms. Create a small space for yourself that inspires you!

"Nature never did betray the heart that loved her."
—William Wordsworth

PANSIES

My aunt adores pansies, and for years, because of her, I've associated pansies with a certain sweetness mingled with perseverance. This pattern pays homage to the power of a diminutive bloom.

Painting tip: Do you find that when you choose to paint, your phone rings, the house is noisy, and email notifications just won't stop? Promise yourself that for at least ten minutes of your painting session you will leave your phone in another room. See what happens.

On being an artist: Artists can find beauty anywhere. Be aware of the subtle beauty in nontraditional places. Keep looking, you never know what you'll see next.

"Art washes away from the soul the dust of everyday life."
—Pablo Picasso

CUTTING GARDEN

Since I was a teenager, I've dreamed of having a cutting garden. Thoughts of strolling knee-high through blooms with a harvest basket in hand and the bumblebees buzzing seem to capture the perfect garden experience. Now my cutting garden dreams have come to life and every season is a gift to behold.

Painting tip: My favorite warm-up is to create a color swatch page. Choose a color palette for your painting and then put your palette on scrap paper. Make a single brushstroke of each color you love. Be sure to clean your brush between each color. This will help you get better acquainted with all your watercolor palette has to offer (see tutorial).

On being an artist: Artists experiment. Not every painting will be wall-worthy, but who cares? Some of my favorite painting sessions resulted in pieces I have shown to very few people. Each painting session is a chance to free fall into your art making. If you are painting for someone else or hoping for admiration, you are snuffing out the full joy of painting.

DAHLIAS

Dahlias have been part of my life for as long as I can remember. My dad grew them every summer and they towered above my head when I was a child. Now I grow over twenty varieties that keep me and my paintbrushes busy from July to October.

Painting tip: If your paper seems too wet with colors that are out of control, let it dry. Practice some brushstrokes on a scrap of watercolor paper. You can also speed up drying with a hairdryer.

On being an artist: Artists need community. A common misconception about artists is that they need solitude to work. I've found the opposite

is true. Make a date with friends to paint together—the conversation will stimulate your creativity.

FUCHSIA

Fuchsia flowers have always mesmerized me. Even as a child, when I was most interested in popping the bulbous blooms before nature opened them, I could not pull my eyes away. These blooms are a perfect combination of graceful petals and round, berry-like shapes. The many flowers, always in various stages of bloom, dangle effortlessly from thin stems and have an enchanting presence.

Painting tip: Watercolor doesn't always need to be soft and flowing. You can begin by washing color onto a slightly damp area and then return to that area after it has dried to add more detail. Smaller brushes are best when you want to add finer brushstrokes. Mix nearly equal amounts of pigment and water for fine details and larger amounts of water for washes.

On being an artist: Artists indulge. As you continue on your artistic journey, reward yourself every so often. Try a new paintbrush. Perhaps you've always wanted to try watercolor pencils, so go purchase a few! Pick up a new book on the meaning of flowers. Artists are forever evolving and more deeply understanding the tools they love most.

MOM'S GARDEN

I recall a bounty of tiny, wild violets growing in our lawn. I would pick handfuls and give them to mom, thinking they were just as pretty as anything growing in the garden. These days her garden is full of foxglove, yarrow, and coral bells, a curious combination of texture, shapely petals, and tiny buds. Every once in a while I still notice those wild violets underfoot.

Painting tip: Often when I step back and examine my paintings, I sense a lack of dynamics. To remedy this, I try to use a variety of vibrant colors, contrasted with muted colors. Consider using a bold, saturated red near a sheer olive green.

On being an artist: Artists love books. Inspiration can come from spending time with a good art book. There is value in the tactile, the things we touch with our hands and feel with our souls. Books have that power.

DESERT BLOOMS

One of my favorite places on earth is Zion National Park. Every May and June the prickly pear cactus begin to reveal blooms in shades of fuchsia, orange, yellow, and red. Indian paintbrush, sagebrush, and yucca also make a powerful appearance. This pattern is meant to capture the desert landscape contrasts.

Painting tip: Complementary colors are those opposite each other on the color wheel. They are friends and look good next to one another, but when mixed together, they become dark. Looking for a brick red? Mix in a bit of green. Want to enliven that purple flower in your painting? Add a few fine yellow brushstrokes nearby (see color wheel).

On being an artist: Artists improvise. It's not always practical to take a trip to the Southwest, so for desert inspiration, pick up a few cactus specimens at your local home store. They need little maintenance but offer up tons of color and texture.

"And if you should be there you see this beautiful cactus blossom painted silver by the moon and laughing up at the stars, this . . . is heaven." —Bryce Courtenay

SUMMER FLOWER BASKET

Every late spring I look forward to visiting the local nursery to select annuals to fill colorful pots around our property. Petunias, geraniums, grasses, and coleus are some of my favorites. There is something quite magical about the way different plants begin to tangle together as they grow.

Painting tip: When you feel your painting is finished, consider adding a bit of shimmer ink for interest (see suggested materials).

On being an artist: Artists travel. Feeling the need for inspiration? Take an hour or two for an impromptu visit to a local greenhouse. Take this book and your paints and brushes, and find a quiet spot to set up. You will be surprised how much a change of scenery can relight the creative fires.

POMEGRANATE AND BLOOMS

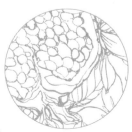

The pomegranate has long been a symbol of health and vitality. This illustration combines a pomegranate slice with leaves, smaller berries,

kumquats, and cherries. Meant to be a lively composition reminiscent of a Dutch Masters painting, this pattern is just calling to be filled with layers of rich and vibrant colors.

Painting tip: See how many different reds you can mix using all the colors on your palette. Strive for thirty!

On being an artist: Artists find joy in the mundane. As a child, I was allowed to raid the produce aisle in our local market. As I chose colorful oranges, peppers, and berries, I was dreaming up my next drawing composition. You don't need fancy props. No, all you need some days is a quick trip to the market.

BEGONIAS

I grew up hearing about my maternal grandmother's talent for growing shade begonias. She would snip the bright, ruffled blooms from their drooping stems and float them in a brandy snifter full of fresh water. This ritual captured every last moment of joy these heirloom blooms had to offer.

Painting tip: Soft peach or coral colors can be tricky to mix. Water is key, as too much pigment will look orange. A bit of orange, a good amount of pink, a touch of red, and a lot of water will be a good starting point on the path to your perfect peach.

On being an artist: Artists know when to step back. My art teacher, Sue Hand (perfect name right?), taught me very early on to get up and back away from my paintings. It is so easy to get lost in the small perspective of palette, brush, and hand. Viewing your painting from a distance gives your eyes a rest and allows you to see areas needing attention.

CHINOISERIE

Chinoiserie motifs are usually characterized by asymmetry, fanciful characters, and a sense of the imaginary. Blooms, lattice, vines, and greenery wreaths find their way around this quirky example of chinoiserie.

Painting tip: Layer watercolor to create increasingly detailed results. Wash a light layer of color in select areas (more water, less pigment—sometimes called glazing—see tutorial). Let dry and repeat with a complementary color. For example, the color blush could be layered onto a light golden color. As you build your layers, use smaller brushes

to add more detail. If you are patient and let each layer dry, the most incredible textures will begin to appear.

On being an artist: Artists Google. Take a moment to Google the word chinoiserie. Get inspired by examples of wallpaper, paintings, and installations. I often begin a painting session with a bit of research to see how others interpret a particular painting style.

HYDRANGEAS

My friend Kelley opened my eyes to the beauty of hydrangeas. I'm more of a big, bold, warm bloom type of gal, but its cool color and lush shape is admittedly captivating. My favorite stage is when each four-petaled flower starts to pop. I love seeing the seedy centers grow into lush balls.

Painting tip: To lay down a lot of color over a large area, grab a big brush and clean painting water. The large brush lets you apply a lot of color quickly before it begins to dry.

On being an artist: Artists can admire and respect almost any painting style. We seems to have a global respect for the process of making art. Sure, my favorite style of painting is not abstract expressionism, but I have sought out opportunities to gaze on Jackson Pollock's dancing pigments on massive canvases.

RANUNCULUS

How can I explain what the ranunculus flower means to me? It is possibly the most iconic of blooms with its densely gathered, paper-thin petals. Color varieties abound and each bloom looks as if God painted it with watercolor himself. Some ranunculus resemble roses, while others look only like themselves—a tumble of whispery petals, bound together with peach-fuzzy green leaves and graceful stems.

Painting tip: Sometimes the fun of watercolor is simply messing around. Grab a scrap sheet of paper and add water, then color, some other color, more water. Watch the color explosions happen, notice what unfolds when you tip your paper at an angle. Add some new color to the page when the paper is tipped. You'll notice quickly that watercolor seems almost alive as it glides and dribbles across the page.

On being an artist: Artists embellish, magnify reality, and evolve the mundane. So be the artist, even if only for fifteen minutes a day!

Vision is the art of seeing what is invisible to others.
—Jonathan Swift

HIBISCUS

In the Northeast we have about three months to enjoy the hibiscus. How exotic it feels to see these large, colorful blooms pop each morning, revealing their bold stamens and showing off those glossy, deep green leaves.

Painting tip: To keep paint flowing in a large area on the page, use plenty of water. If watercolor paint begins to dry, you will notice hard edges of color that refuse to blend with other colors on the page.

On being an artist: Artists color outside the lines. You may be tempted in this book to apply watercolor neatly inside the lines. Don't. Let your watercolor washes flow and meander over and around the illustration. There is no rule that requires you to keep your brush focused within a particular shape.

HAWAIIAN BLOOMS

In my teen years, tropical blooms were my go-to form of doodling. I painted these powerful flowers on every surface possible. This pattern combines the classic island beauties: bird of paradise, plumeria, orchids, and heleconia.

Painting tip: Maintaining a watercolor look when using bold color can be a challenge. Watercolor is meant to have a sheer, luminescent quality, so don't forget to put some water on your brush. Watercolor is meant to flow, even when you are applying heavier layers of pigment.

On being an artist: Artists escape. Our world is crazy, friends. These days we have more to do, look at, and be distracted by than ever before. Artists have a keen ability to escape their distractions, to be somewhere else, in a place more gratifying and spirit-building than technology could ever be.

COLUMBINE AND BERRIES

Have you ever looked at a columbine flower? I mean really looked? Someone once told me that the columbine brought them to a spiritual place because of the incredible amount of intricate detail in the bloom.

Painting tip: Columbine are typically purple and pink. Clean your brushes between colors or you might end up with pinkish-purple blooms everywhere. Clean water is essential. I change my painting water every half hour or so.

On being an artist: Artists harvest. Pick flowers as often as you can. Many of the weeds growing in your yard are a stunning counterpoint to showy, cultivated blooms.

To see a world
in a grain of sand
And a heaven in a wild flower,
Hold infinity in the palm of your hand
And eternity in an hour.

– William Blake

To See a world
in a grain of sand
And a heaven in a wild flower,

Hold infinity in the palm of your hand

And eternity in an hour.

— William Blake

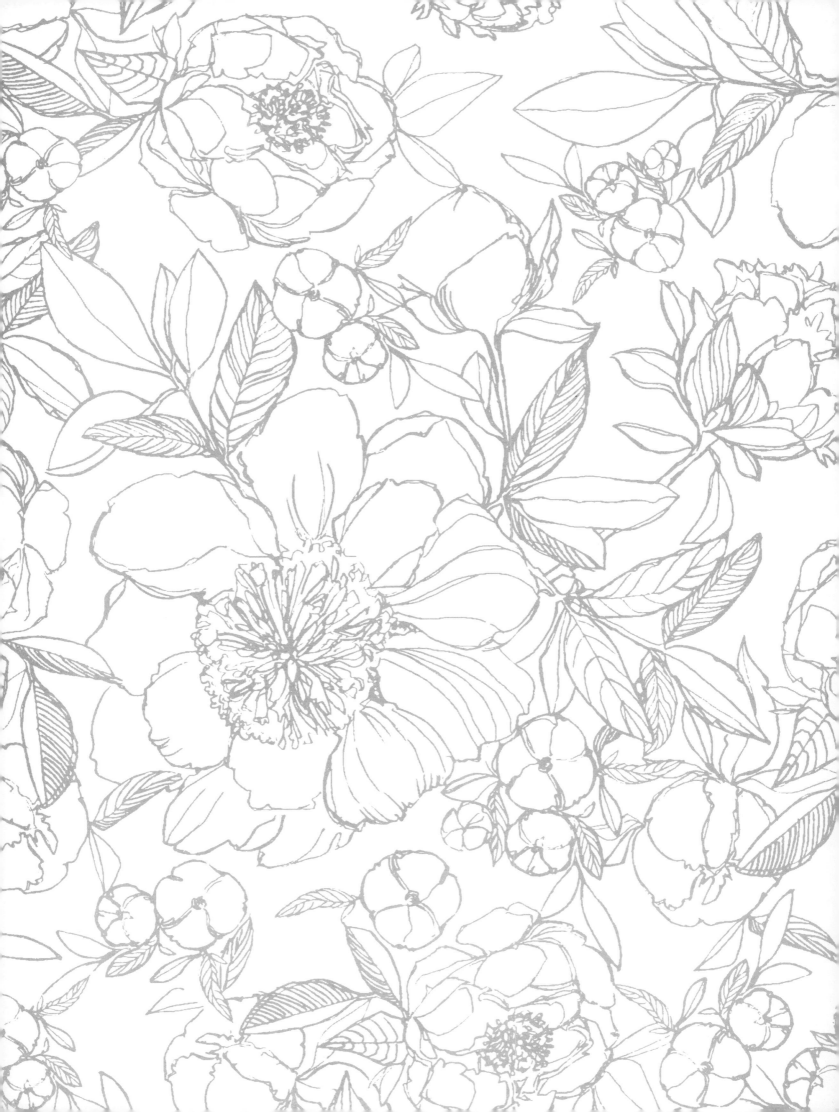

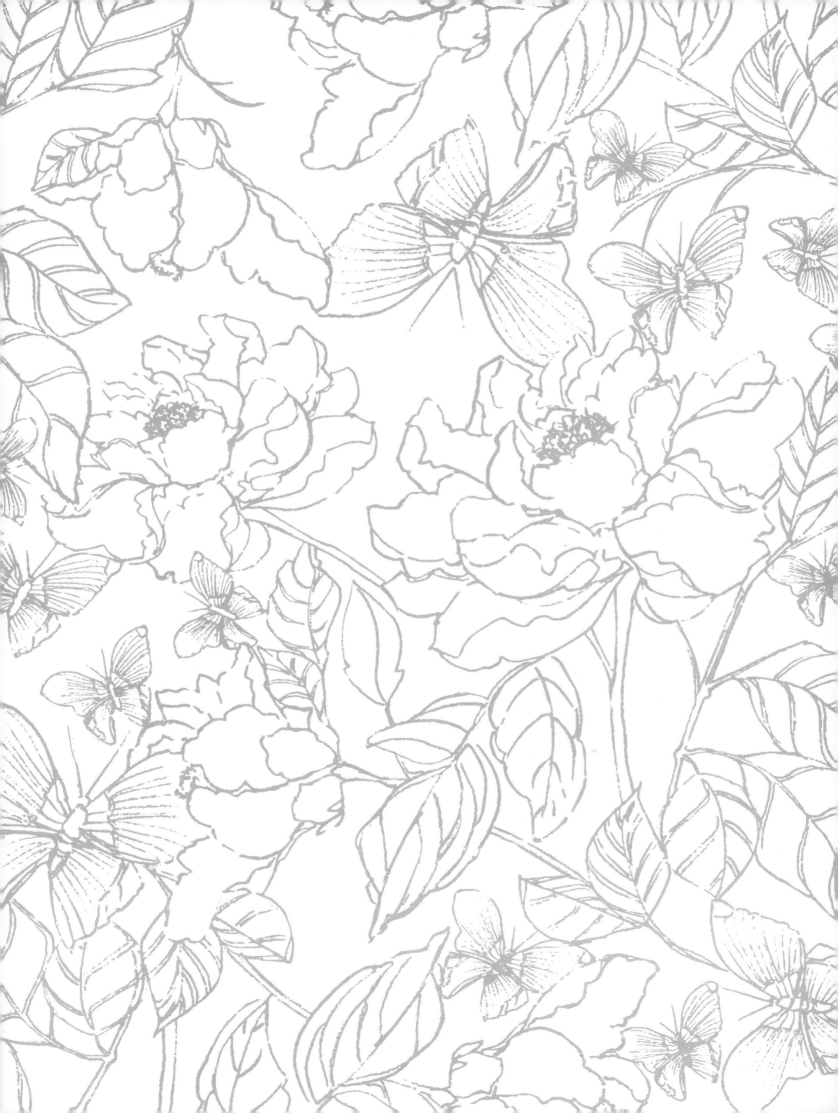

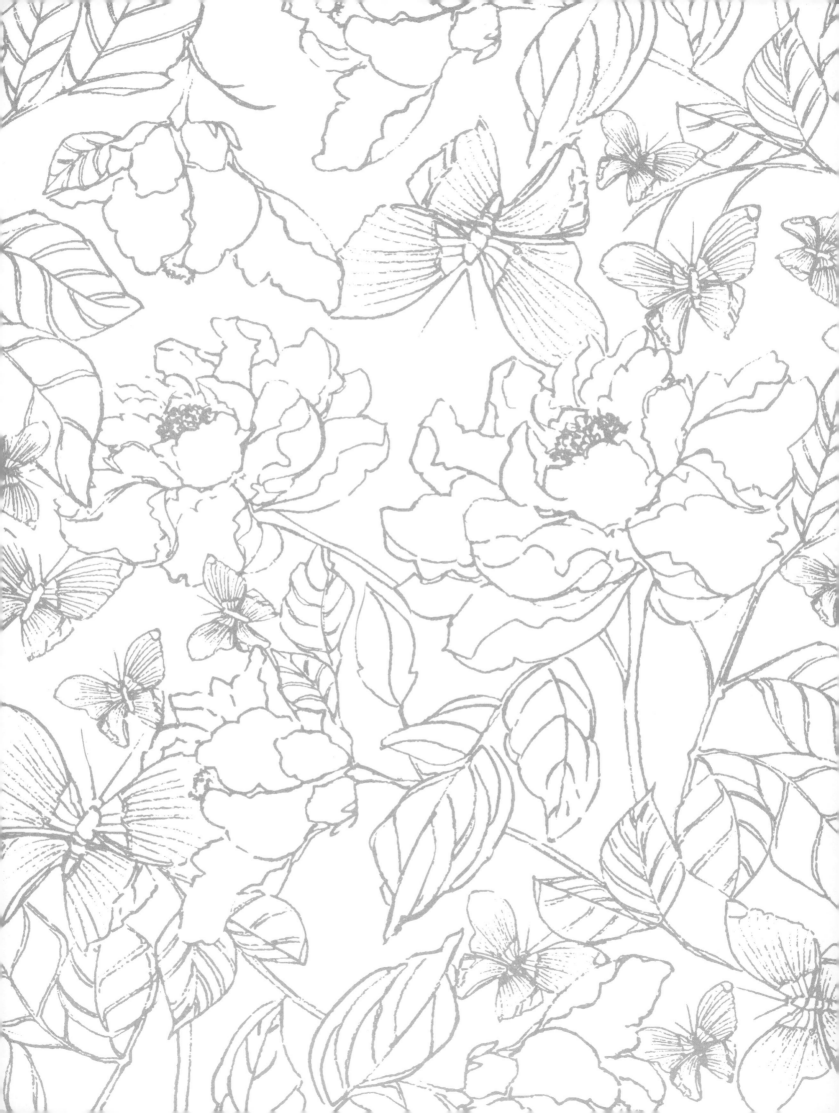

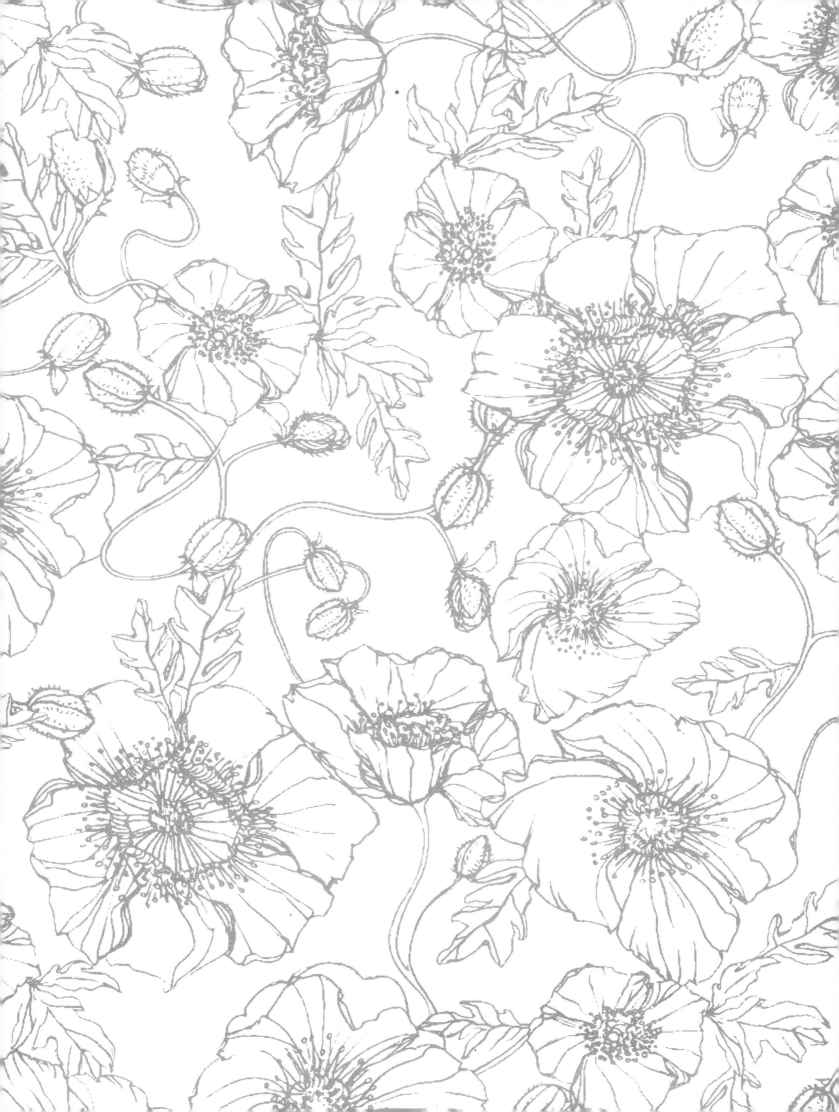

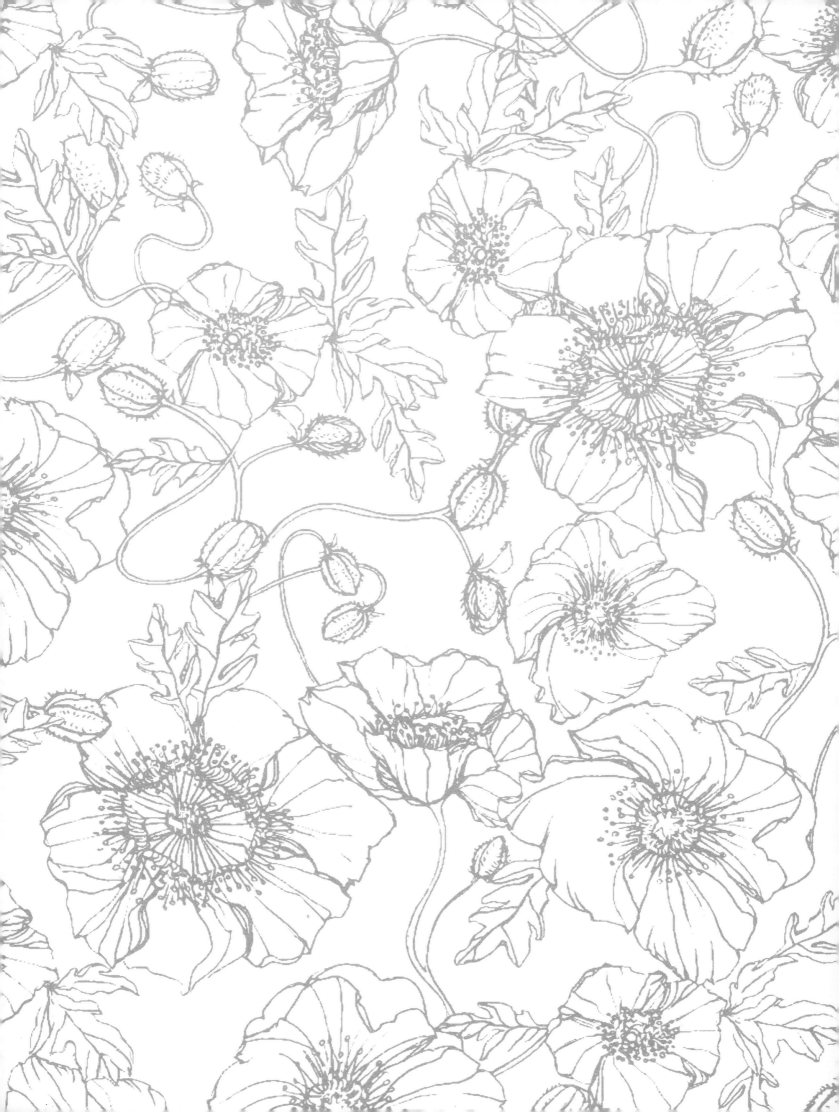

Just living is not enough...
one must have sunshine, freedom,
and a little flower.
—Hans Christian Andersen

Just living is not enough...
one must have sunshine, freedom,
and a little flower.
— Hans Christian Andersen

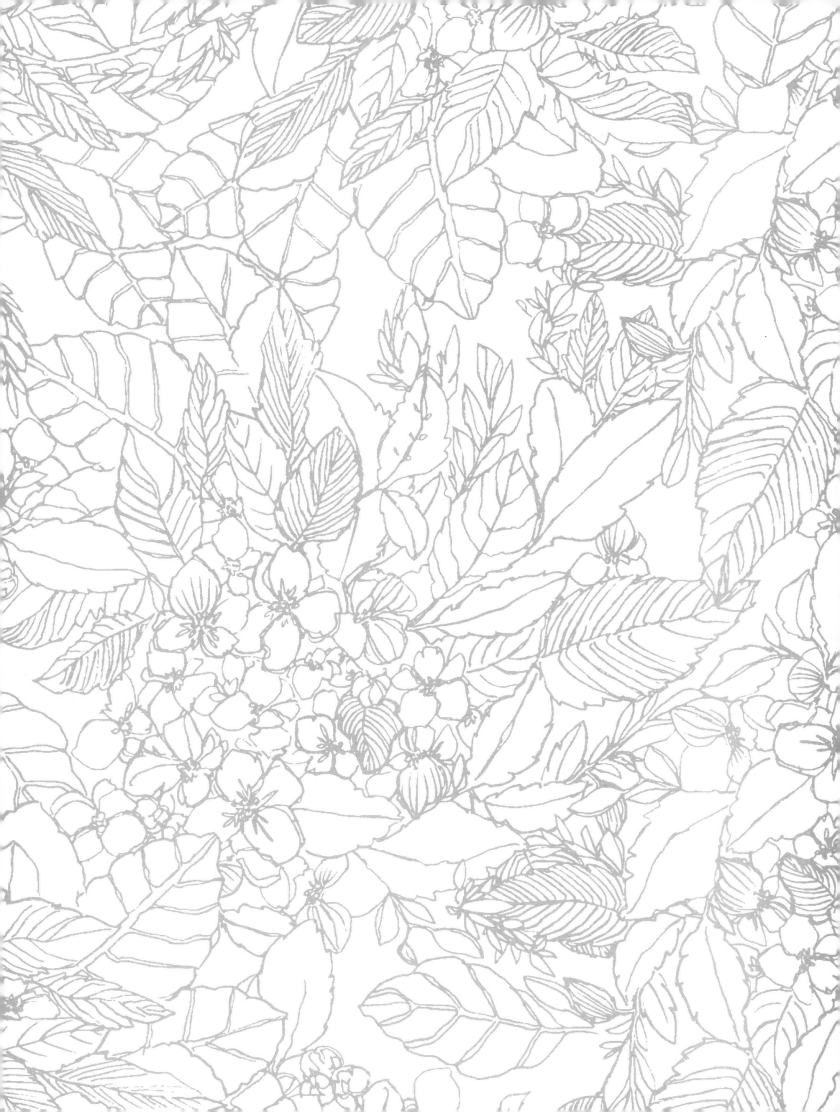

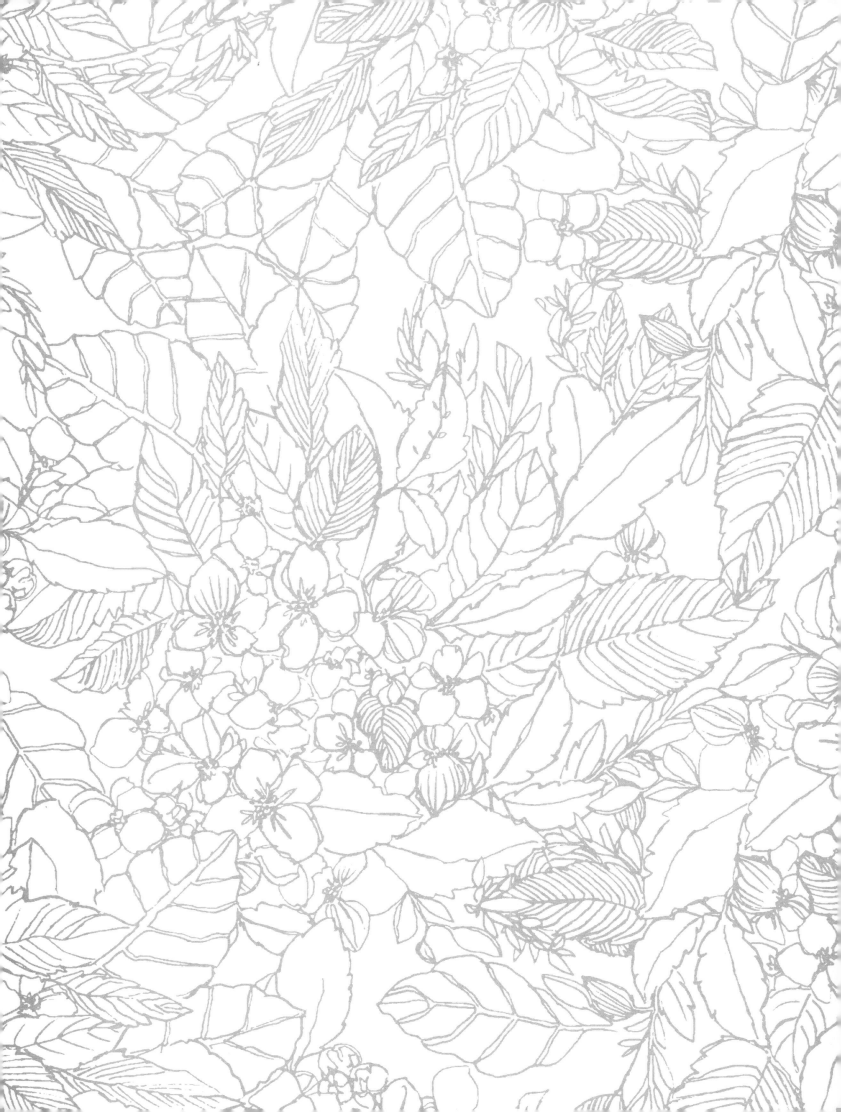

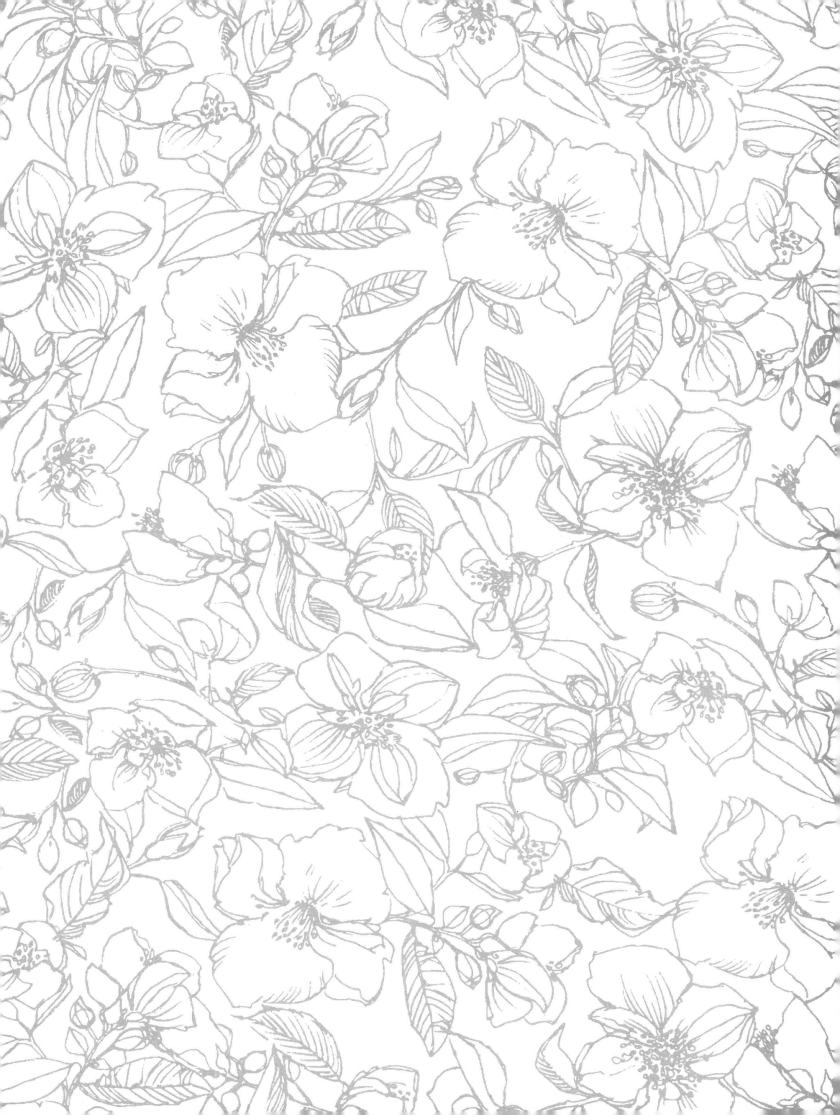

The amen of nature
is always a flower.

-Oliver Wendell Holmes, Sr.

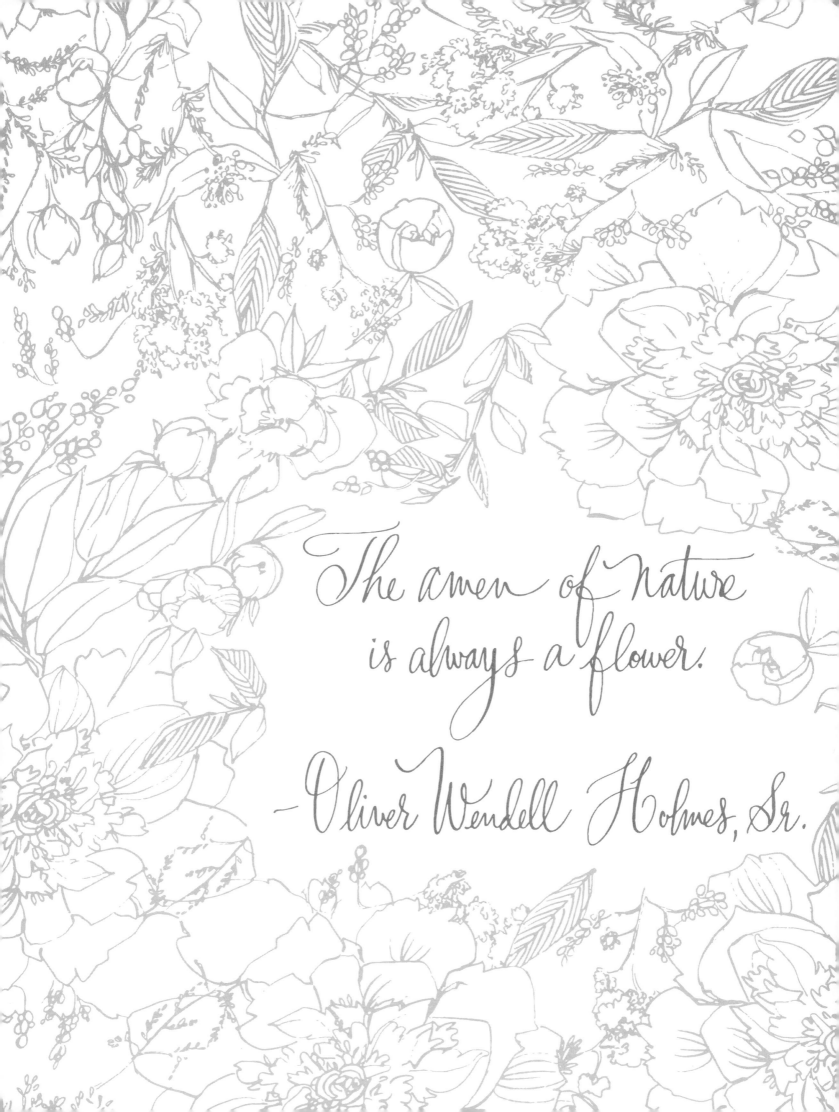

The amen of Nature
is always a flower.

-Oliver Wendell Holmes, Sr.

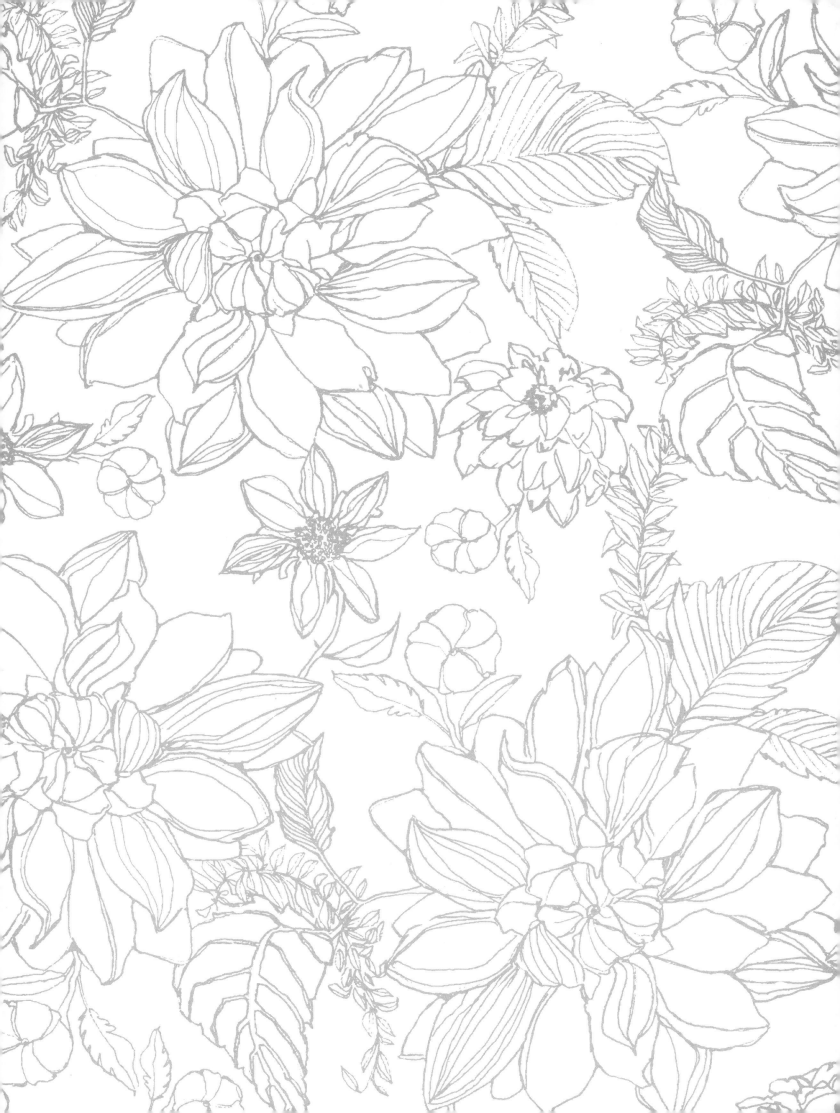

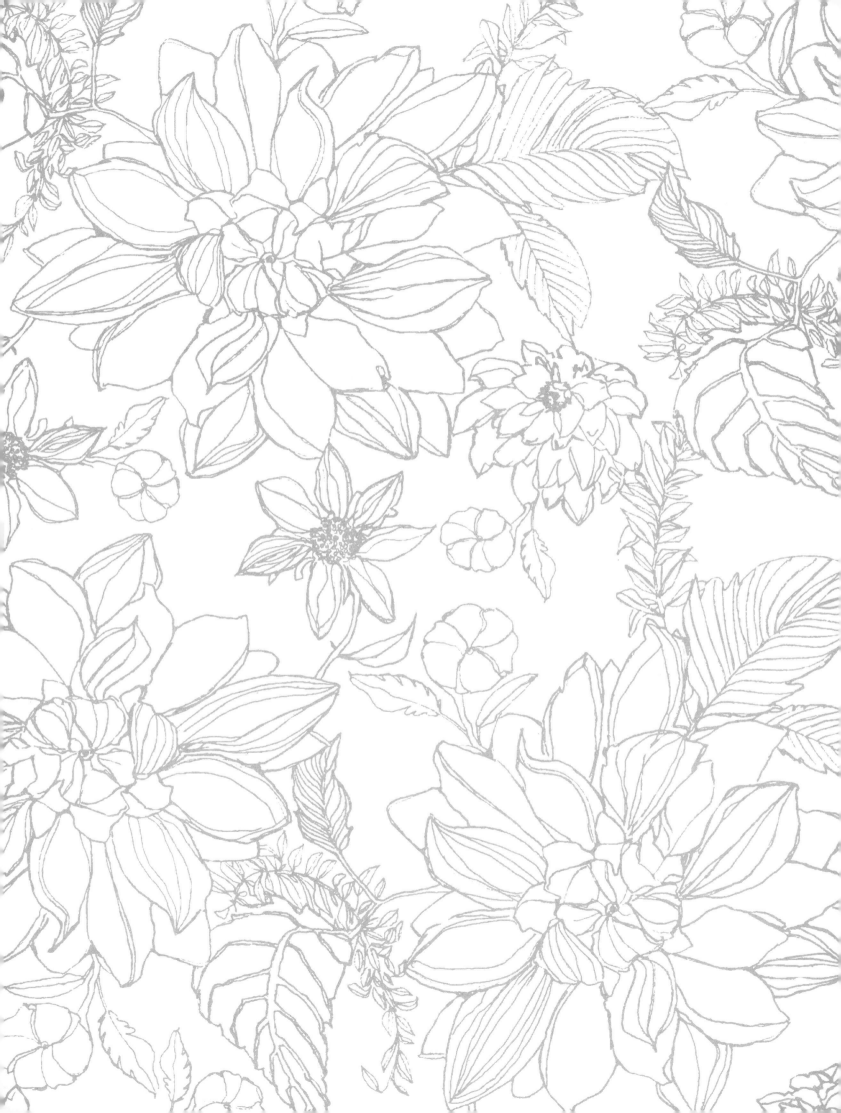

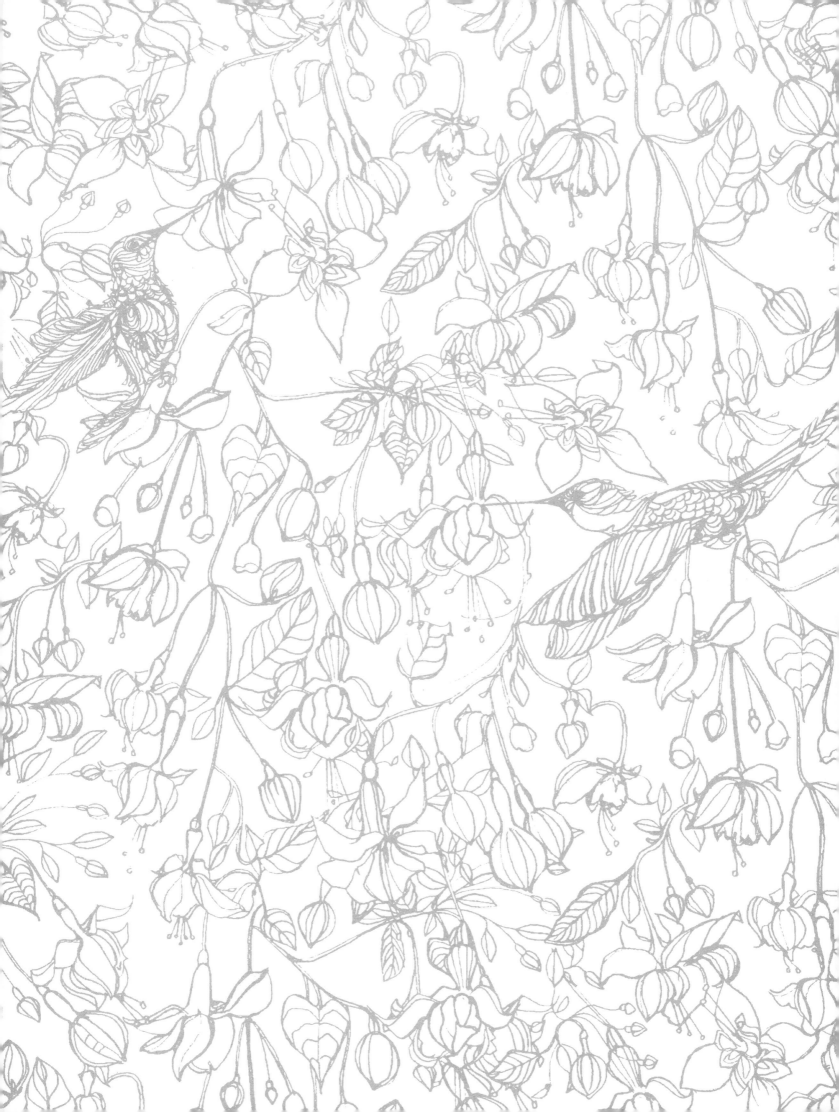

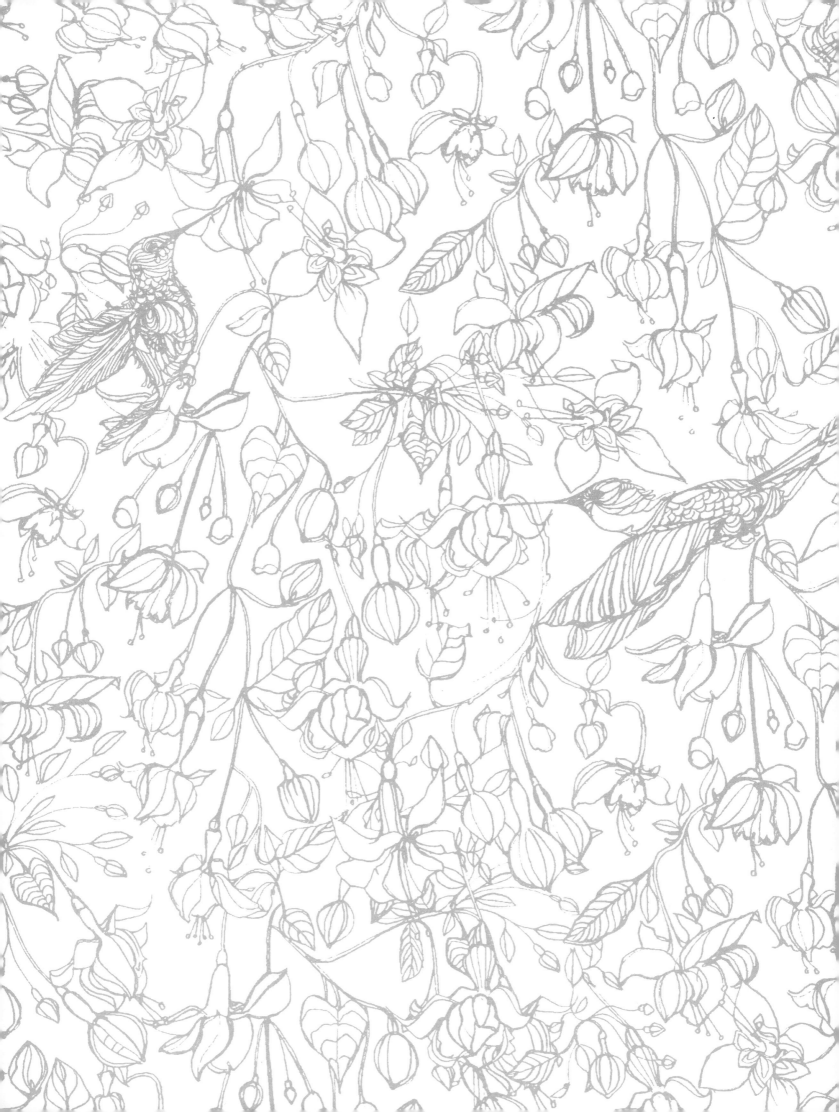

Nobody sees a flower
really; it is so small.
We haven't time, and to
see takes time ~ like to have
a friend takes time.

~ Georgia O'Keeffe

Nobody sees a flower really; it is so small. We haven't time, and to see takes time — like to have a friend takes time.

~ Georgia O'Keeffe

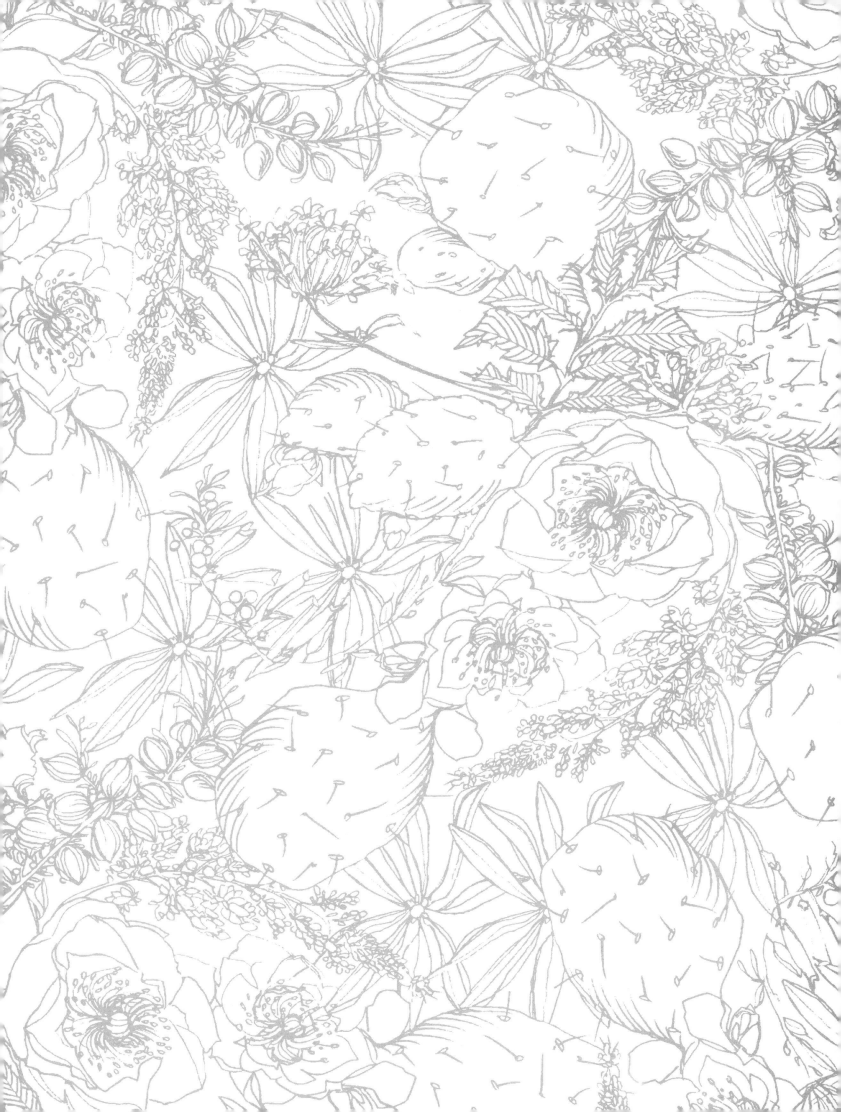

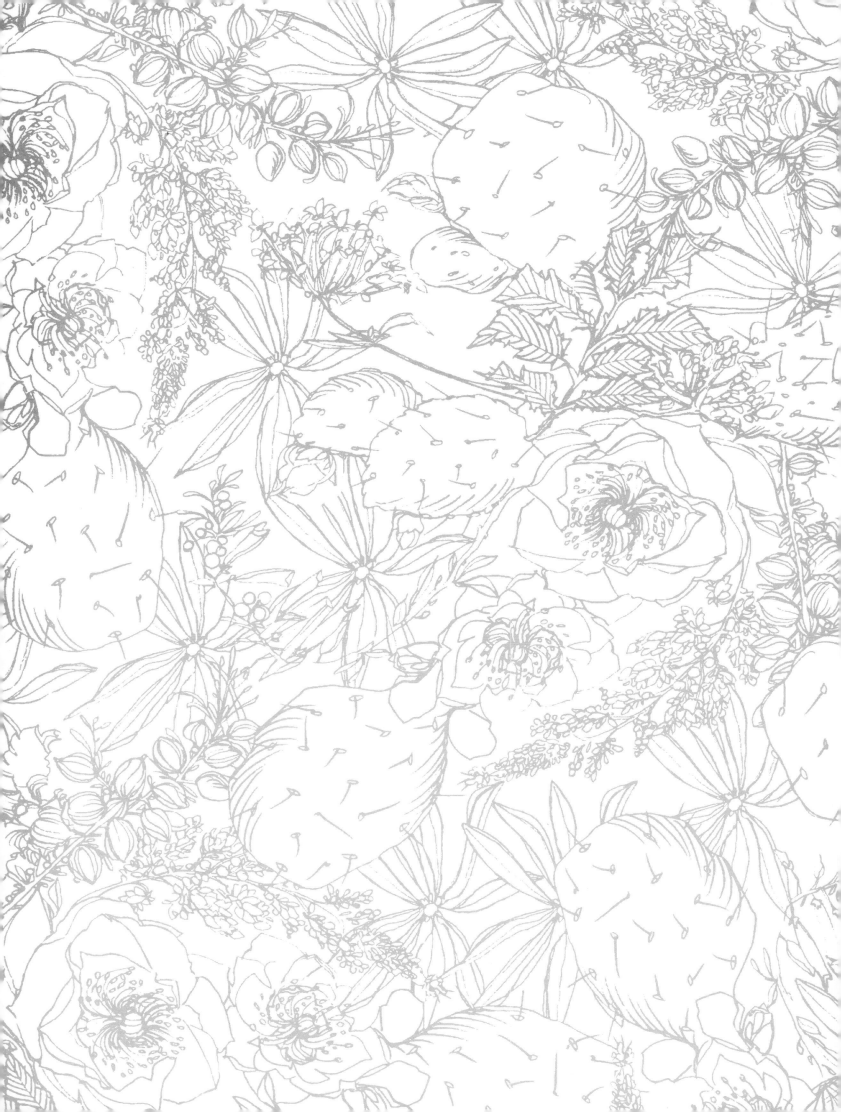

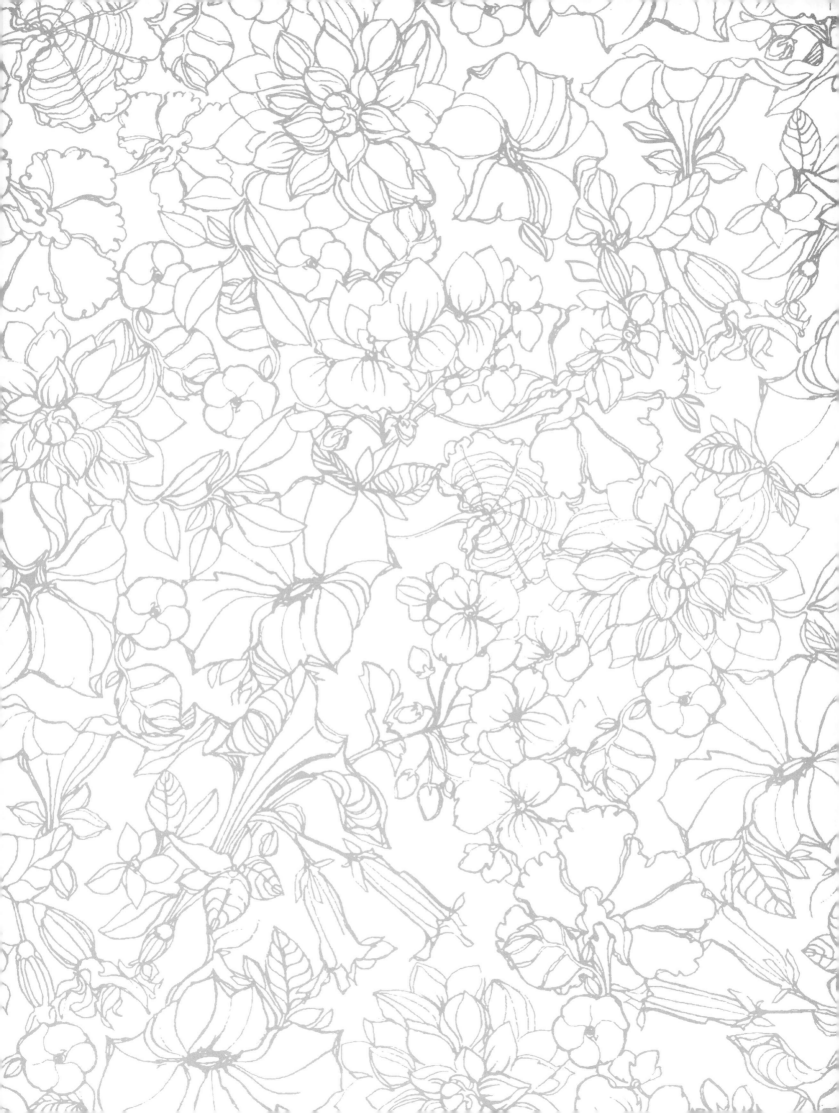

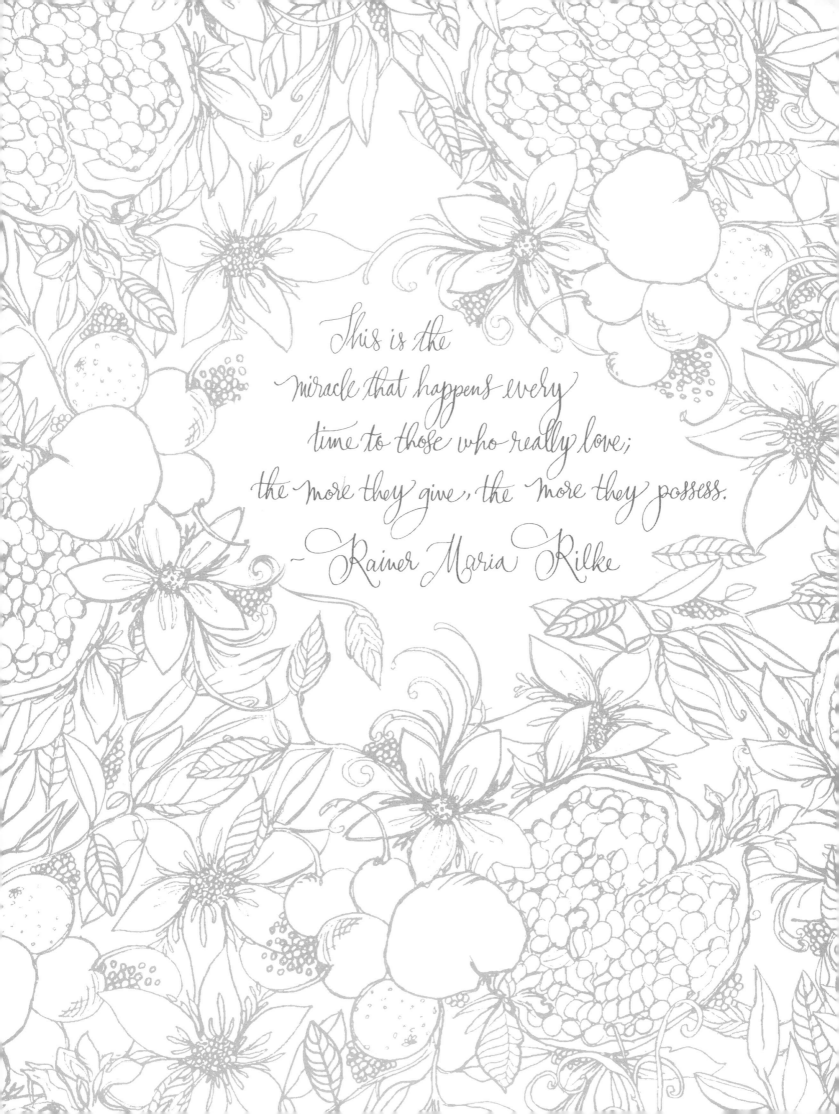

This is the
miracle that happens every
time to those who really love;
the more they give, the more they possess.
~ Rainer Maria Rilke

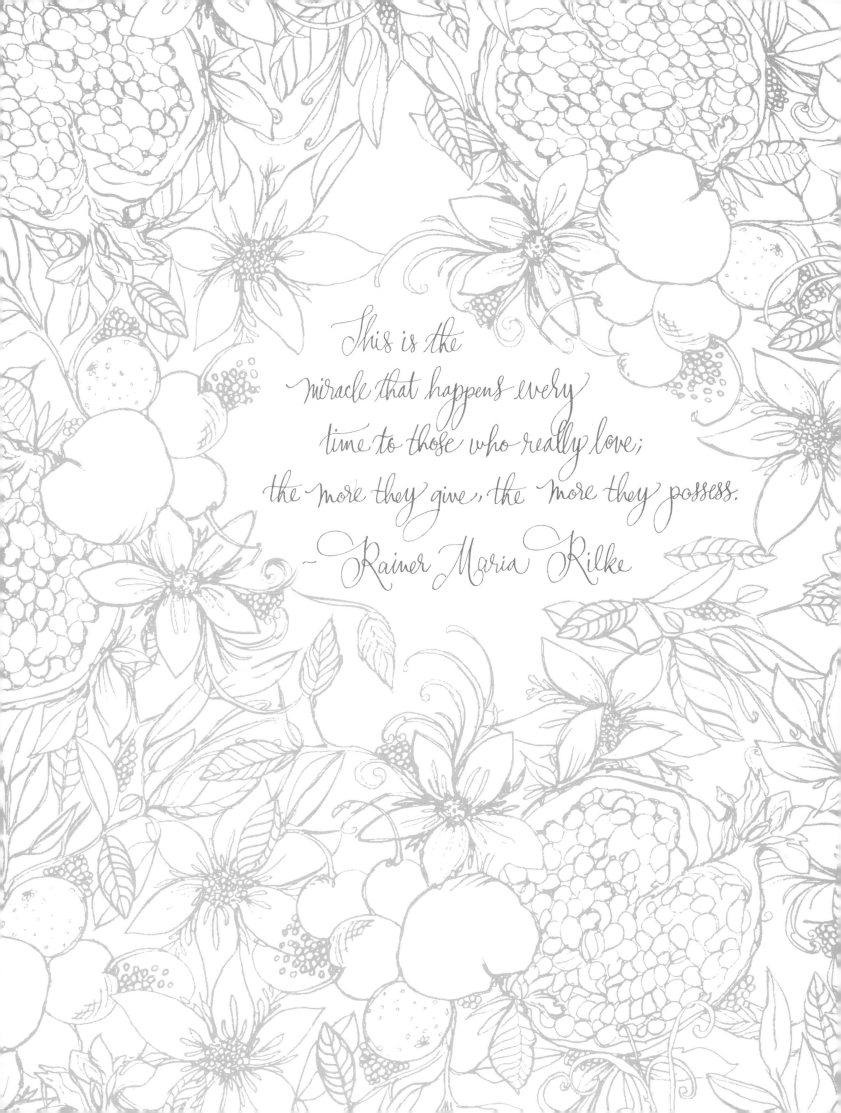

This is the
miracle that happens every
time to those who really love;
the more they give, the more they possess.
~ Rainer Maria Rilke

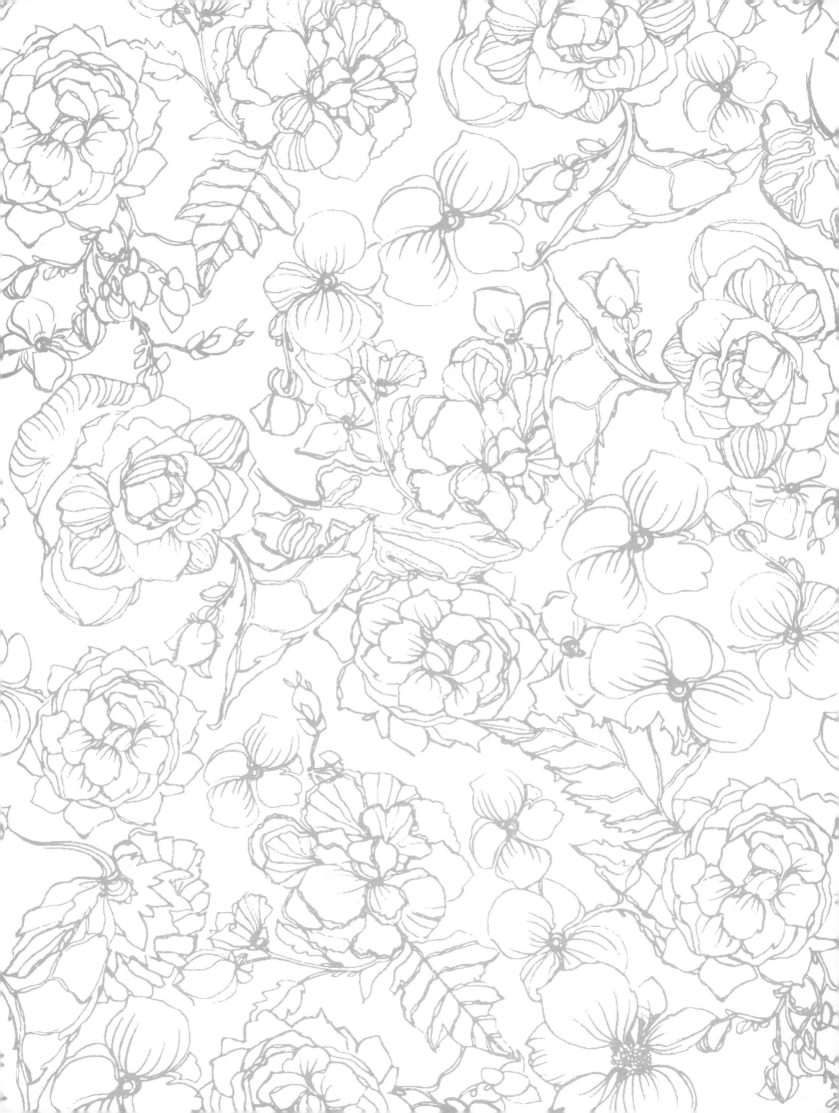

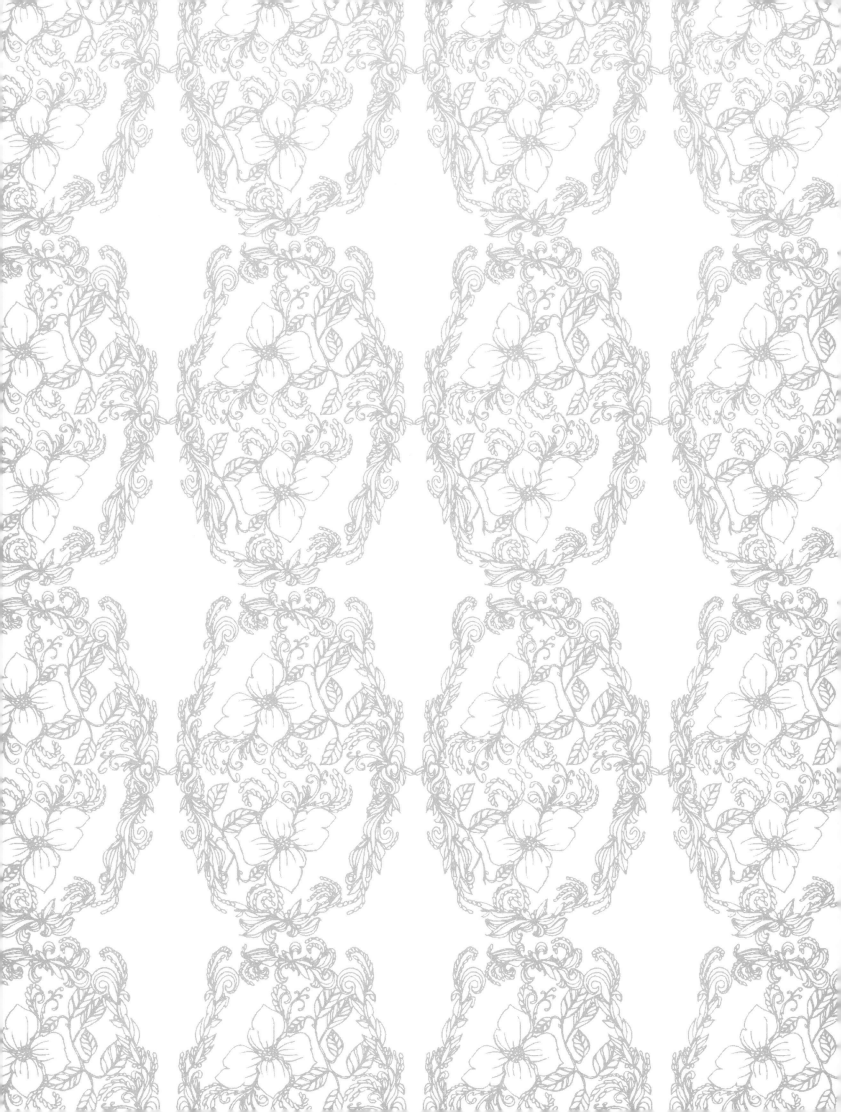

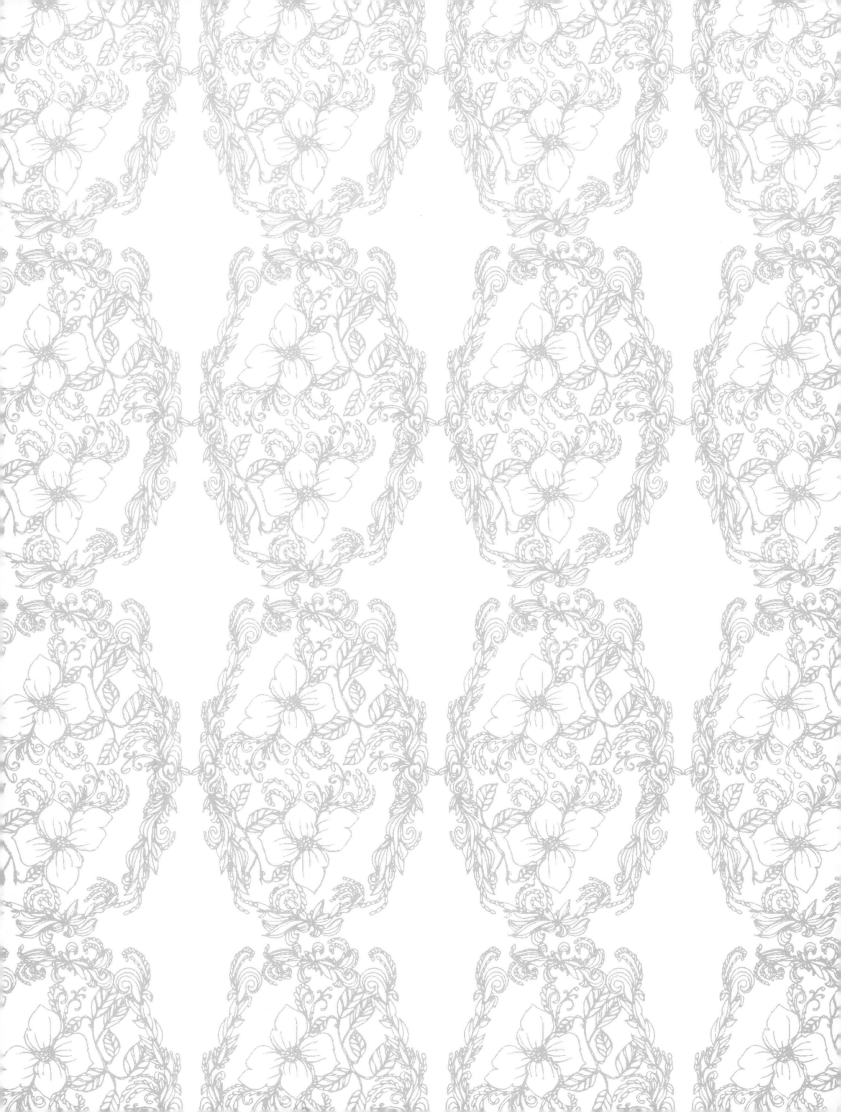

When you take a flower in your hand,
and really look at it, it's your world for the moment.
I want to give that world to someone else.
Most people in the city rush around so,
they have no time to look at a flower.
I want them see it whether they want to or not.

~ Georgia O'Keeffe

When you take a flower in your hand,

and really look at it, it's your world for the moment.

I want to give that world to someone else.

Most people in the city rush around so,

they have no time to look at a flower.

I want them see it whether they want to or not.

~ Georgia O'Keeffe

The amen of nature
is always a flower.
-Oliver Wendell Holmes, Sr.

The amen of Nature
is always a flower.
—Oliver Wendell Holmes, Sr.

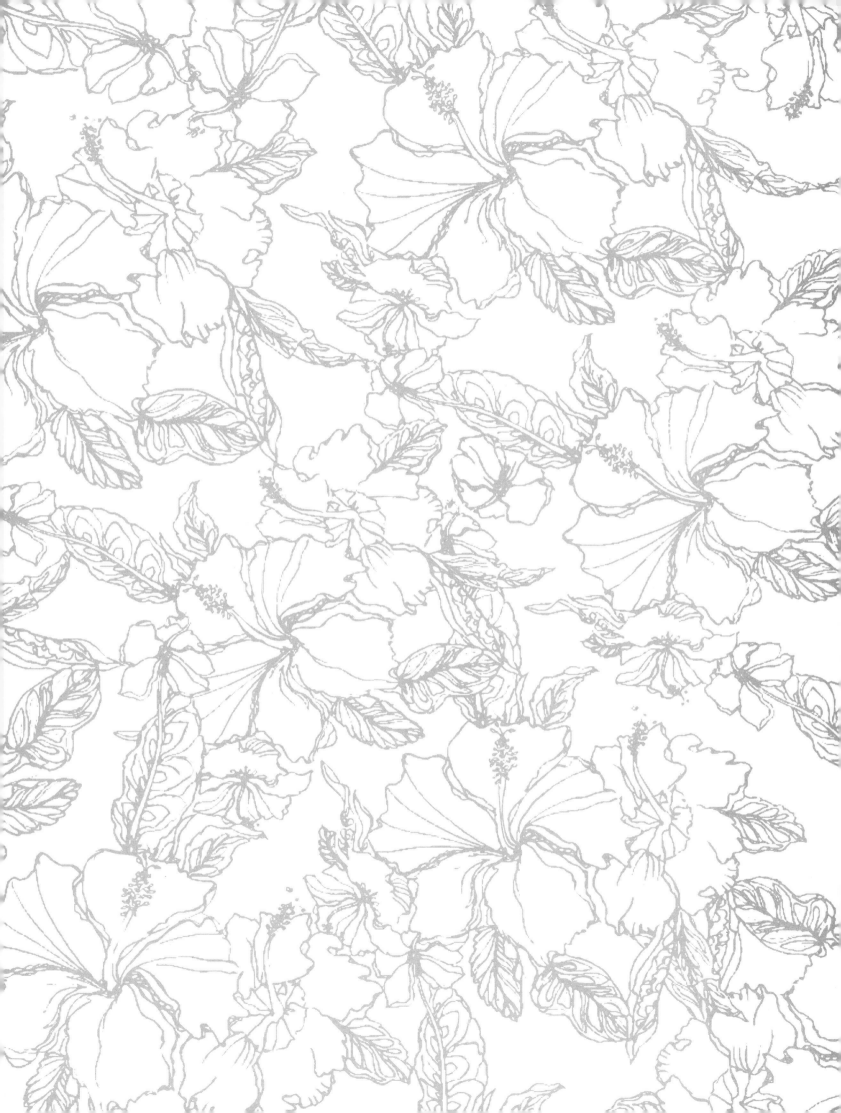

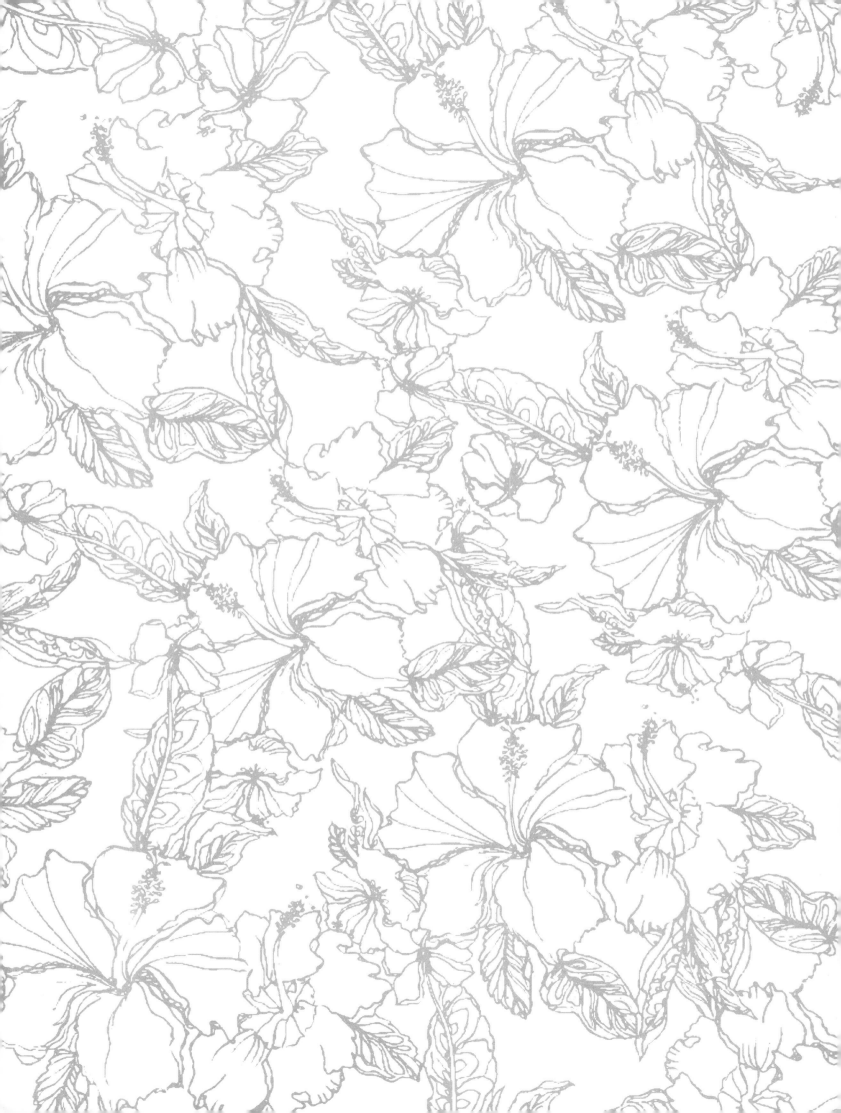

The artist is
the confidant of nature,
flowers carry on dialogues with him
through graceful bending of their stems
and the harmoniously tinted
nuances of their blossoms.
Every flower has a
cordial word which nature directs
towards him.
~Auguste
Rodin

The artist is
the confidant of nature,
flowers carry on dialogues with him
through graceful bending of their stems
and the harmoniously tinted
nuances of their blossoms.
Every flower has a
cordial word which nature directs
towards him.
— Auguste
Rodin

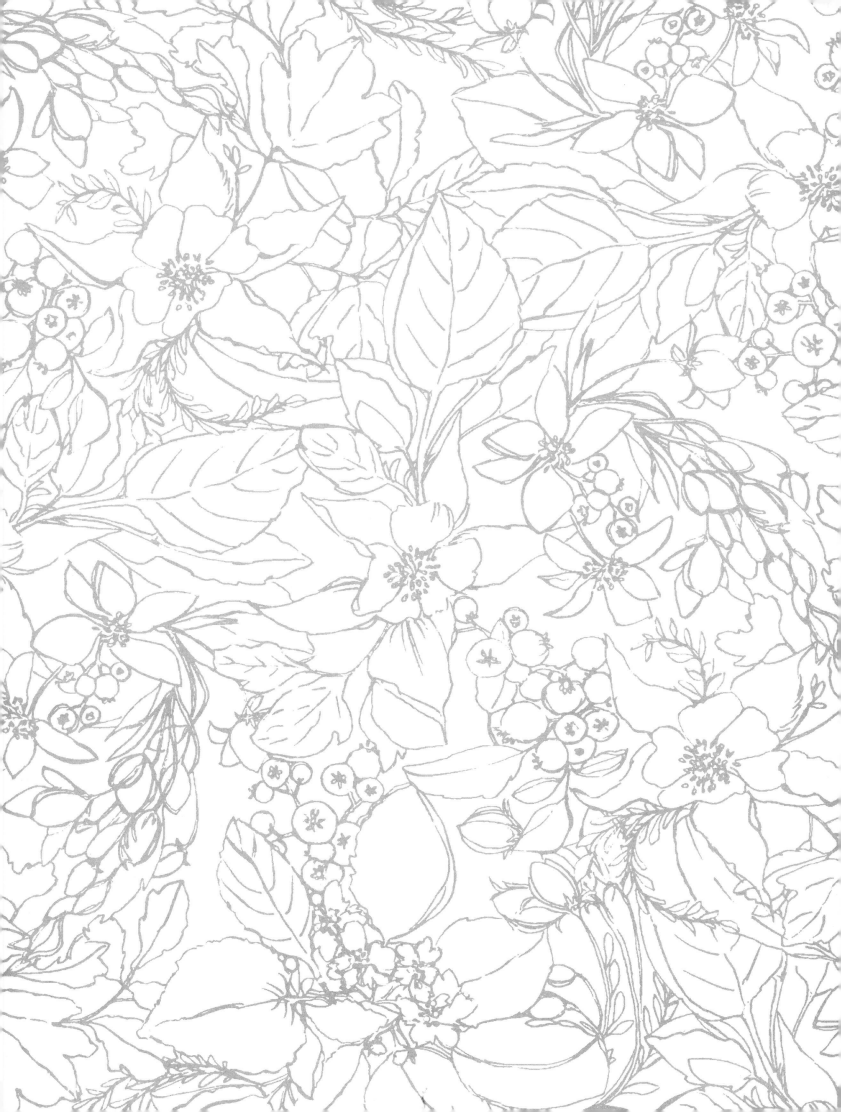

Acknowledgments

This book is the result of sincere and heartfelt collaboration. Without the insight and smarts of so many whom I hold dear, these adult watercoloring books would not be possible.

To Amy, my best friend and kindred spirit, who instilled in me the confidence to write in the first place.

To the Momentals who give me the space and time to make these crazy dreams come true.

To Kelley, Katie, Steph, and Jillian for always lending an ear and being brutally honest.

To Lara for capturing my heart in her words.

To Sue and the Art Zone for teaching me to love getting lost in art.

To Rachel for coming on board and making things happen fast.

To Laura for her saving graces.

To Madison for her fierce skills and impassioned talent. You've taught me.

To Kristen for her good eye.

Notes

C. S. Lewis, *The Voyage of the Dawn Treader* (New York: HarperCollins, 2006).

William Wordsworth, "Lines Composed a Few Miles above Tintern Abbey, on Revisiting the Banks of the Wye during a Tour," July 13, 1798.

Pablo Picasso. BrainyQuote.com, Xplore Inc, 2015. http://www.brainyquote.com/quotes/quotes/p/pablopicas162882.html, accessed July 6, 2015.

H. C. Andersen, *Hans Christian Andersen: The Complete Fairy Tales* (Ware, UK: Wordsworth Editions, 2009).

Auguste Rodin. BrainyQuote.com, Xplore Inc, 2015. http://www.brainyquote.com/quotes/quotes/a/augusterod169875.html, accessed July 6, 2015.

D. H. S. Nicholson and A. H. E. Lee, *The Oxford Book of English Mystical Verse*. (Oxford: Clarendon Press, 1917).

O'Keeffe, Georgia, *Georgia O'Keeffe* (New York: Viking Press, 1976).

Victor Hugo. BrainyQuote.com, Xplore Inc, 2015. http://www.brainyquote.com/quotes/quotes/v/victorhugo152577.html, accessed July 6, 2015.

Laurie Lisle, *Portrait of an Artist: A Biography of Georgia O'Keeffe* (New York: Seaview Books, 1980).

Oliver Wendell Holmes, Sr. BrainyQuote.com, Xplore Inc, 2015. http://www.brainyquote.com/quotes/quotes/o/oliverwend152690.html, accessed July 6, 2015.

Maria Rainer Rilke and Franz Xaver Kappus, *Letters to a Young Poet* (New York: Norton, 1954).

Carleton Varney, *In the Pink: Dorothy Draper: America's Most Fabulous Decorator* (New York: Shannongrove Press, 2012).